WORD AS IMAGE

WORD AS IMAGE

Ji Lee

A PERIGEE BOOK

A PERIGEE BOOK

Published by the Penguin Group
Penguin Group (USA) Inc. 375 Hudson Street, New York, New York 10014, USA
Penguin Group (Canada), 90 Eglinton Avenue East, Suite 700, Toronto, Ontario M4P 2Y3,
Canada (a division of Pearson Penguin Canada Inc.)
Penguin Books Ltd., 80 Strand, London WC2R 0RL, England
Penguin Group Ireland, 25 St. Stephen's Green, Dublin 2, Ireland (a division of Penguin Books Ltd.)
Penguin Group (Australia), 250 Camberwell Road, Camberwell, Victoria 3124,
Australia (a division of Pearson Australia Group Pty. Ltd.)
Penguin Books India Pvt. Ltd., 11 Community Centre, Panchsheel Park, New Delhi—110 017, India
Penguin Group (NZ), 67 Apollo Drive, Rosedale, Auckland 0632,
New Zealand (a division of Pearson New Zealand Ltd.)
Penguin Books (South Africa) (Pty.) Ltd., 24 Sturdee Avenue, Rosebank, Johannesburg 2196, South Africa

Penguin Books Ltd., Registered Offices: 80 Strand, London WC2R 0RL, England

While the author has made every effort to provide accurate telephone numbers and Internet addresses
at the time of publication, neither the publisher nor the author assumes any responsibility for errors or for changes
that occur after publication. Further, the publisher does not have any control over and does not assume
any responsibility for author or third-party websites or their content.

WORD AS IMAGE

PERIGEE is a registered trademark of Penguin Group (USA) Inc.
The "P" design is a trademark belonging to Penguin Group (USA) Inc.
First edition: October 2011

ISBN: 978-0-399-53695-3

PRINTED IN MEXICO
10 9 8 7 6 5 4 3 2

Most Perigee books are available at special quantity discounts for bulk purchases for sales promotions, premi-
ums, fund-raising, or educational use. Special books, or book excerpts, can also be created to fit specific needs.
For details, write: Special Markets, Penguin Group (USA) Inc., 375 Hudson Street, New York, NY 10014.

Dedicated to my love, Clarina Bezzola

About *Word as Image*

When we were children, letters were like fun toys. We played with them through our building blocks. We colored them in books. We danced and sang along with TV puppets while learning C was for "cookie." Soon, letters turned into words. Words turned into sentences. Sentences turned into thoughts. And along the way, we stopped playing with them and stopped marveling at A through Z.

Word as Image brings a little magic back to the alphabet by helping us see the fun and humor behind the lines and squiggles.

This project started nearly twenty years ago as an assignment in my typography class at art school. Students were encouraged to see letters beyond their dull, practical functionality. We played with their unique shapes and tinkered with their infinite possibilities. The challenge was hard, so the reward of "cracking" a word felt great. This became a lifelong project for me.

Anyone can create a word as image. It doesn't require any design or drawing skills. All you need is a little creative thinking and to see words and letters in a different way. The dictionary is filled with thousands of fun visual puzzles just waiting to be solved. Visit www.wordasimage.com to submit your solution.

Please enjoy!

Ji Lee

Word as Image

Create an image out of a word, using only the letters contained within the world itself.

Use only the shapes of the letters in the word without adding extra parts.

The Alphabet

A B C D E F G H I J K L M
N O P Q R S T U V W X Y Z

a b c d e f g h i j k l m
n o p q r s t u v w x y z

!dea

ELEVATOR

HORIZON

OO

Ball ns

MAGNE+ISM

YING☯NAY

COMEDY
DRAMA

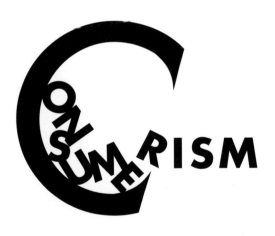

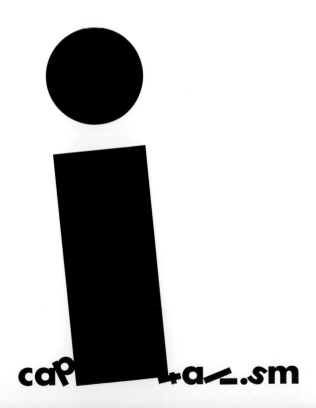

capitalism

OH

NA

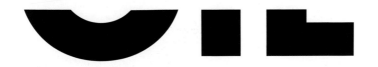

CHRISTIANITY

HRISTIANIT

RISTIANI

ISTIAN

SIN

thelastsupper

1 2 3 4 5 6 7 8 9 10 11 12

VAMPIRE

MIRRORRIM

Smi)e

High

ROBBE⊤Y

NIXON

INFLATI,OOO,OOO,OOON

STOCK MARKET

PSY

SILICONE

sports

sports steroids

sports steroids

steroids

BIRTHTAED

KARMA
KARMA

PL▶Y

PA❙❙SE

ST◻P

RE◀◀IND

REC●RD

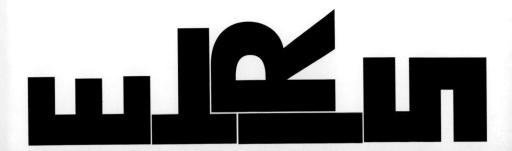

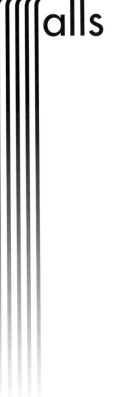

Niagara Falls

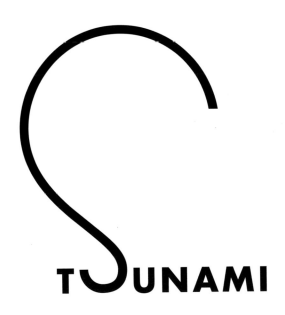

PRAX

TITANIC

SPIDER AN

W

RMAN

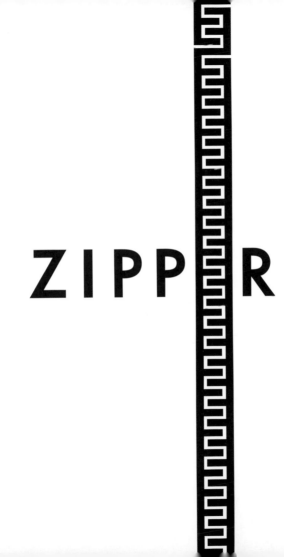

ZIPPER

PANAMA

WEST EAST

KOREA

ISRAEESTINE

ECUADOR

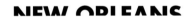

NEW ORLEANS

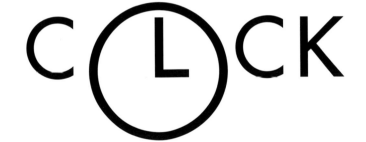

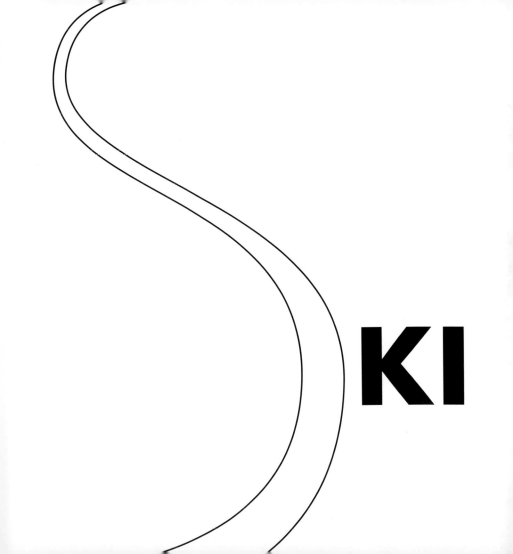

A
A
A
Avalanche

KNI

EVEL

EVEL

PIRATE

x *enophobia*

HUL

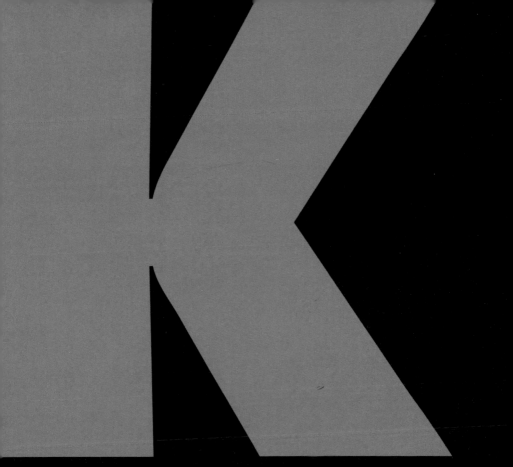

EXIT

Mag c

blind

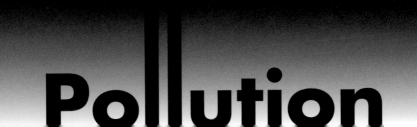

Pollution

GLOBAL WARMING

AMAZON

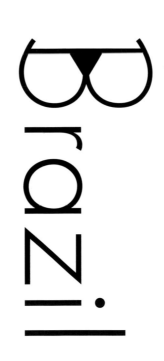

Good

FAST **FOOD**

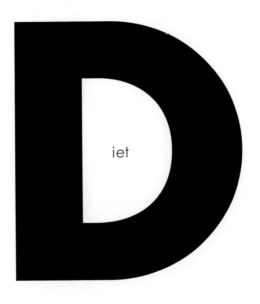
iet

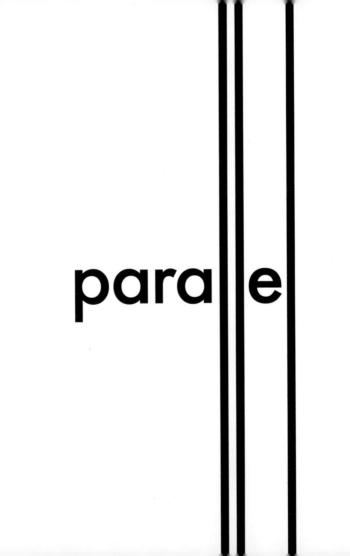

Tun

nel

Rabbit

HOMOSEXUALS
HOMOSEXUALS
HETEROSEXUALS

MEN'S ROOM

QUIT

X-RAY

Illus·ə·n

SUPERSTITIOU S

1 2 3 4 5 6 7 8 9 10 11 12 13

VAN GOGH

SCARFACE

HEAVY METAL

Aging

mory

sleep

ECLIPSE

ECLIPSE

Make Your Own Word as Image

Anyone can make a word as image. All it takes is seeing the letters as shapes and playing with them. Draw them with pen or pencil.

BASIC RULE

Use only the shapes of the letters contained in the word itself, without adding outside parts.

TIPS

On the following pages find some useful tips to create a word as image.

SHARE

Send your word as image to submit@wordasimage.com.

EXTENDING

S TSUNAMI	para‖e‖	DALI

ROTATING AND FLIPPING

ELEVATOR	!dea	MIRRⓄЯЯIM

SEEING LETTERS AS OBJECTS

C⊙CK	ROBBEⸯY	cigaretttttt

COVERING

HₒRIZᴼN ⌣Iᴸ Mag c

LETTER "i" AS A PERSON

≡ ⸱ CAP**i**ꞱALISM Illus·ƏN

PLAYING WITH SCALE

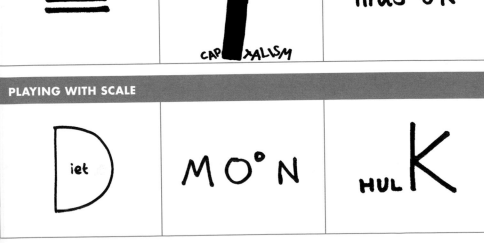

Diet MOᵒN HUL K

MORE TIPS

Try spelling the words in both all caps and upper- and lowercase letters.

Rotate the letters and try seeing them as objects, then think about a word that contains that letter.

Head of a deer / Cocktail glass / Funnel / ?

Megaphone / Eye / Tip of a pencil / ?

Mountain top / Ladder / Pyramid / ?

C

Bullhorn / Horseshoe / Glass / ?

Rising sun / Toilet seat / Head / ?

Screaming mouth / Magnet / Fat belly / ?

Vampire teeth / Hooray! / ?

Fish mouth / ?

Mountain / Flying bird / Graph / ?

THANK YOU!

CHARLES NIX: my typography teacher and an amazing designer who taught me everything I know about typography. He gave this project as a class assignment when I was a student, and also gave me very helpful suggestions about this book.

CLARINA BEZZOLA: my wife, a loving supporter who always gives me so much.

MOM & DAD: who always support me and helped me see the world in a different way.

JEFF GREENSPAN: a friend who's always there for me, who helped me so much with this book.

JAMES LEVINE & LINDSAY EDGECOMBE: my literary agents who saw the potential of this project and gave many great ideas and incredible support to make it happen.

MARIA GAGLIANO & PERIGEE: editor, publisher and collaborator for this book who believed in it.

STEFAN SAGMEISTER: a mentor, a friend who always inspires me.

SETH GODIN, CHRISTOPH NIEMANN: for the wonderful blurbs about the book.

STEVEN HELLER: who has been a great supporter.

LAETITIA WOLFF: who has supported this project from very early on.

THE END